HOW TO
CATCH THE ACTION

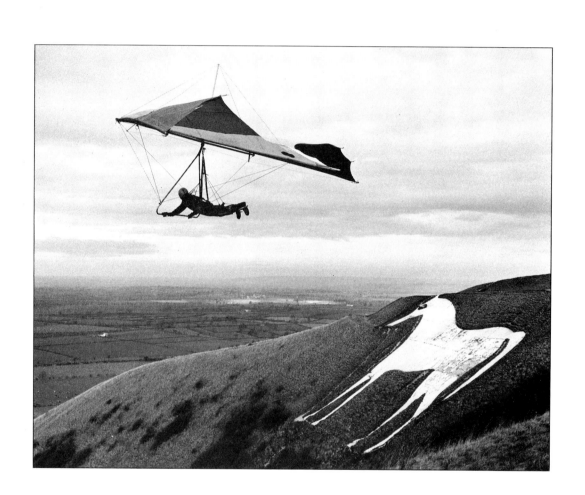

HOW TO
CATCH THE ACTION

Published by Time-Life Books in association with Kodak

HOW TO CATCH THE ACTION

Created and designed by Mitchell Beazley International
in association with Kodak and TIME-LIFE BOOKS

Editor-in-Chief
Jack Tresidder

Series Editor
John Roberts

Art Editor
Mel Petersen

Editors
Louise Earwaker
Richard Platt
Carolyn Ryden

Designers
Marnie Searchwell
Michelle Stamp
Lisa Tai

Picture Researchers
Brigitte Arora
Nicky Hughes
Beverly Tunbridge

Editorial Assistant
Margaret Little

Production
Peter Phillips
Jean Rigby

Consulting Photographers
Tony Duffy
Steve Powell

Coordinating Editors for Kodak
John Fish
Kenneth Oberg
Jacalyn Salitan

Consulting Editor for Time-Life Books
Thomas Dickey

Published in the United States
and Canada by TIME-LIFE BOOKS

President
Reginald K. Brack Jr.

Editor
George Constable

Library of Congress catalog card number 82-629-78
ISBN 0-86706-215-0
LSB 73 20L 06
ISBN 0-86706-217-7 (retail)

Contents

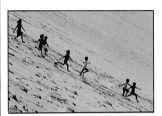
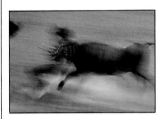
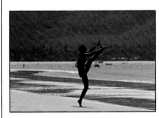

THE DRAMA
OF MOVEMENT

Catching the peak of the action with a camera is one of photography's greatest pleasures. Wherever there is life, there is action – and photographers need much the same skills to capture the headlong charge of a football player, the leap of a marlin from the sea or the thrill of a child's first bicycle ride. The opportunities are unlimited and the techniques outlined in this book will enable you to tackle them all.

The picture on the opposite page represents the summit of the action photographer's art. To achieve this remarkable view required a special remote control setup and the kind of access only a few professionals will be allowed. But the techniques are those you can use in more approachable circumstances, and the equipment is essentially the same as that available to amateurs on a budget. With ingenuity, you can even take fine pictures of pro sports events from a public seat in the stands. And you can take marvelously informal pictures, such as those of the boys on the following two pages, on the beach or in your backyard.

The camera can work miracles – stopping an insect's wingbeats or a speeding bullet in the blink of a stroboscopic flash. However, action photography is only partly about freezing images to make time stand still. Movement can take many forms, from the explosive energy of a sprint to the drifting rhythms of a dance, and deliberate blurring of an image sometimes better conveys the nature and feeling of an action. This book explores many different techniques of recording and expressing movement. And it shows that good action pictures are more often the result of skill and preparation than of sheer luck.

The boiling action of a basketball game freezes in an image of almost formal beauty. To catch the tense, upturned faces as the ball grazed the hoop edge, the photographer fixed the camera above the net and triggered the shutter at a speed of 1/500 by using a remote release.

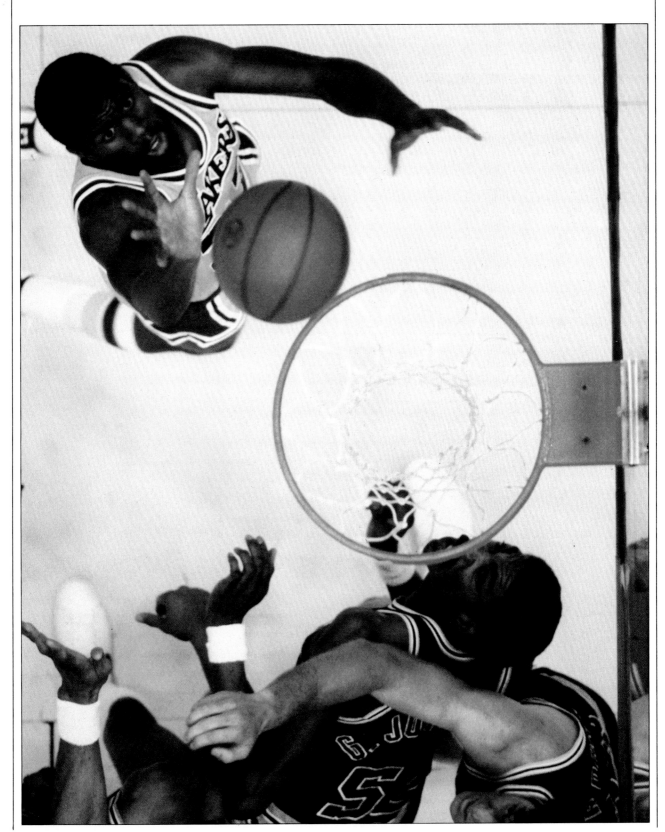

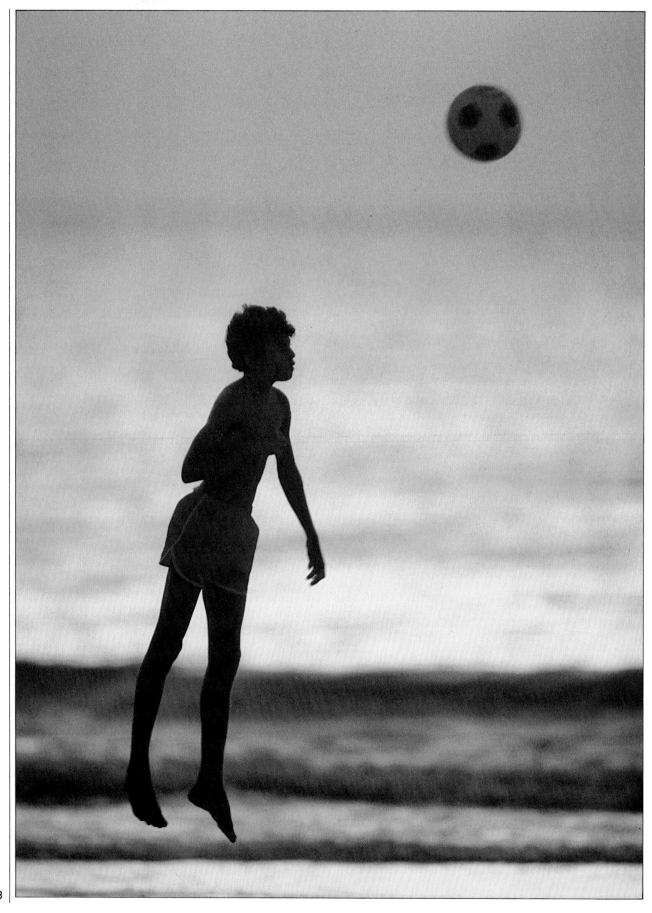

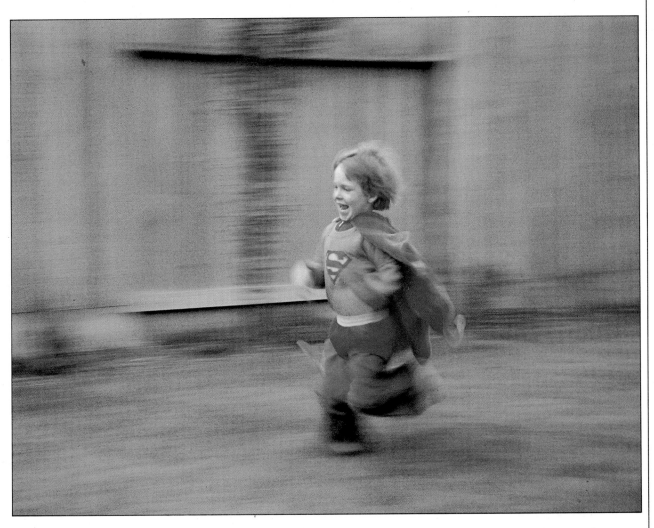

A fast shutter (left)
crisply suspends a boy in
midair as he heads a soccer
ball. The picture was taken
at a speed of 1/500 at f/5.6,
to underexpose the backlit
subject against a soft,
unfocused background.

A slow shutter (above)
combined with the panning
technique conveys a child's
imagined speed as he plays
Superman. Following the boy
with the camera at 1/15 as
he crossed the frame created
streaks of moving color in
the background, and blurred
the rapid motion of his legs
so that he seems almost
about to take off.

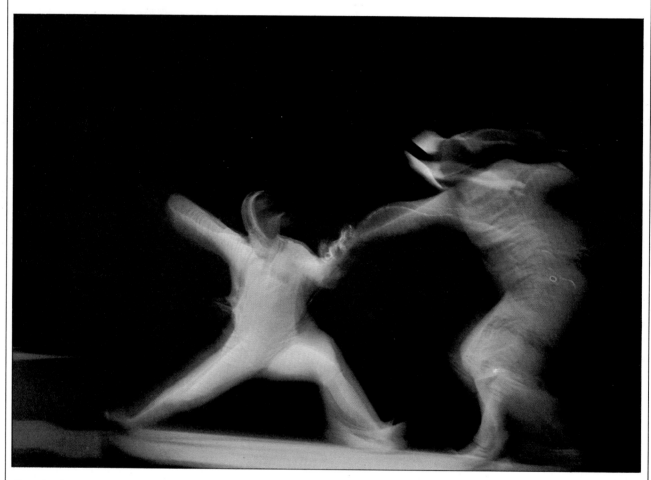

Fencing's elegance is captured (above) in a spectral image. A slow shutter of 1/8 had the effect of dissolving the figures' swift motions against the dark backdrop.

The graceful arc of a gymnast's legs slicing the air (right) appears in consecutive images by means of a stroboscopic flash unit firing rapid flashes. The continuous illumination from overhead stadium lights picks up a sweeping amber trace. The gymnast's iron stillness and the multiple images of his legs suggest both speed and control.

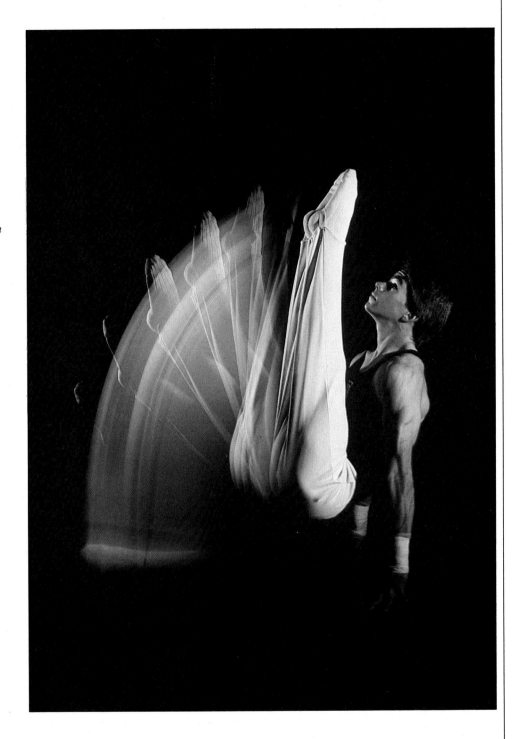

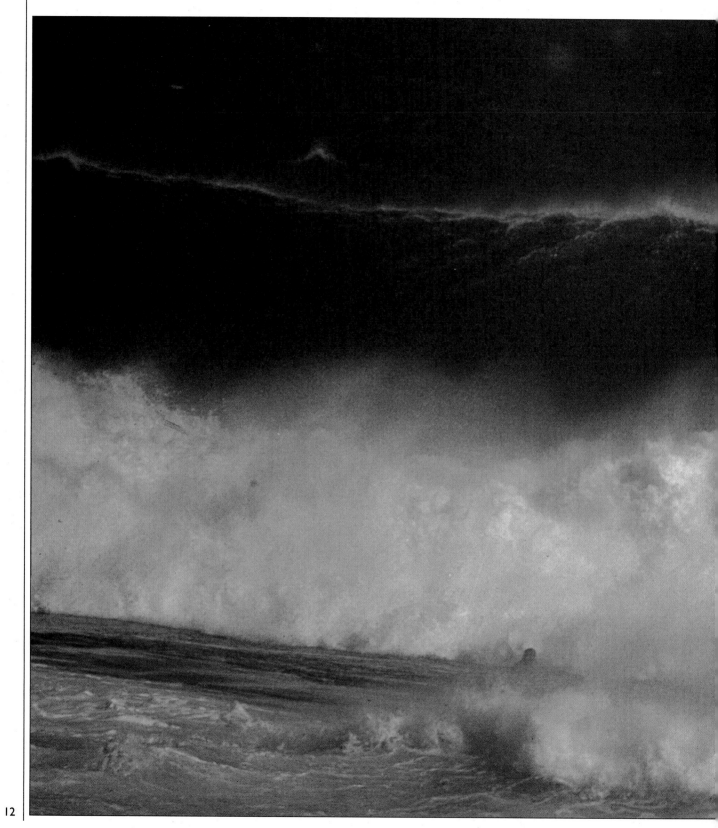

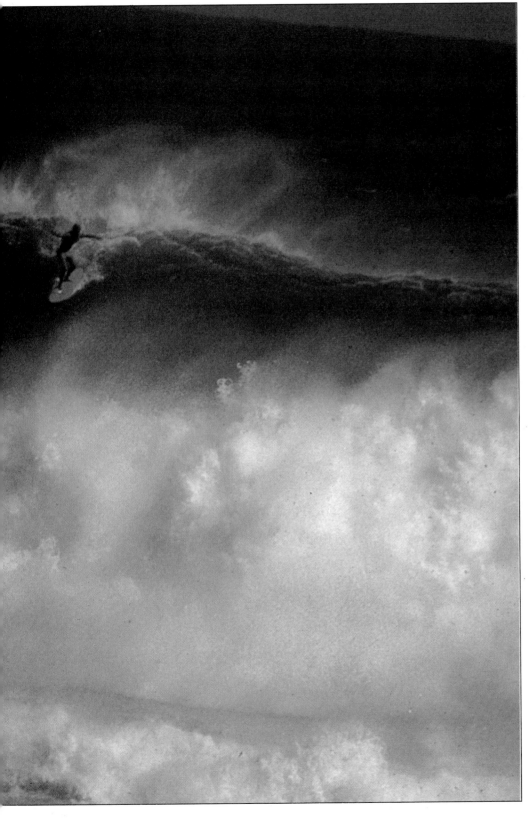

The power of the sea
and the precarious speed
of a surfer combine in a
breathtaking picture. Ernst
Haas, a master of color and
movement, waited until the
surfer stood upright on his
board at the wave's crest.
He set a shutter speed of
1/500 to arrest the surfer,
relying on the plunge of the
wave to suggest the speed at
which he is skimming. The
shutter is not fast enough
to totally freeze the foam
that buried another surfer.

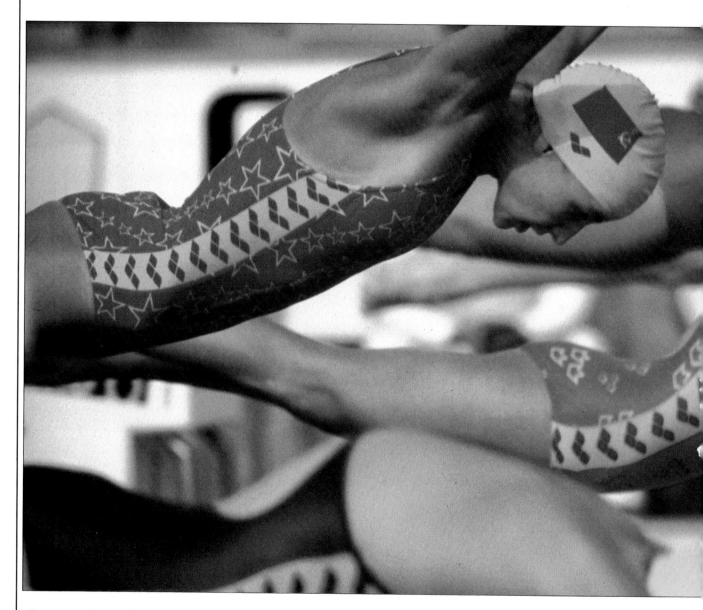

Swimmers launch their bodies toward the water at the start of a race. Arched backs generate a sense of powerful propulsion, and the eel-like limbs, crammed into the frame by a telephoto lens, are stopped with a shutter speed of 1/1000.

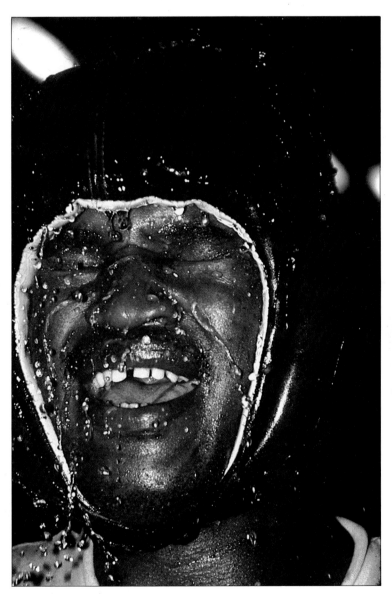

Sweat and water spray
*from the contorted face of
Larry Holmes as he ends a
punishing sparring session
in preparation for a world
heavyweight title defense.
The ringside photographer
closed in and used flash
to freeze the droplets.*

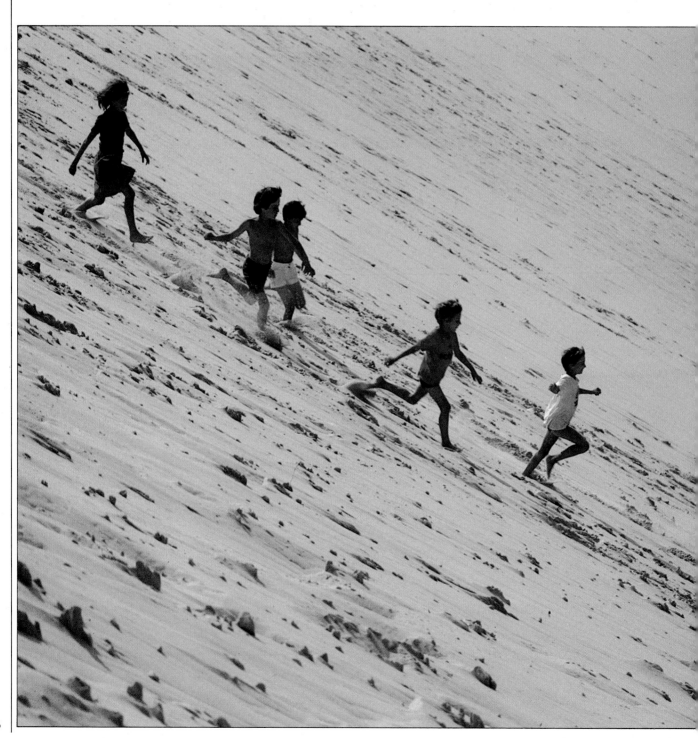

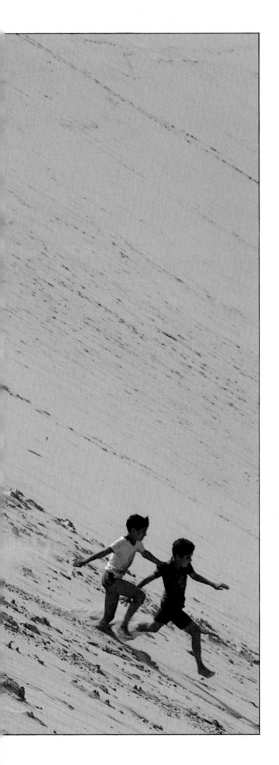

BASIC ACTION TECHNIQUES

Shutter speed is the essential means of control in action photography. In good light, you can make exposures fast enough to freeze almost any rapidly moving subject with a clarity never visible to the eye. With the right equipment, you can maintain adequate shutter speeds even in duller light, and the section that follows discusses the merits of fast film and fast lenses in achieving this. It also explains how to use the technique of panning to freeze motion at slow shutter speeds – a skill that will greatly extend your control over moving subjects and your ability to convey a convincing impression of speed.

However, good action photography depends on more than the mechanical speed of your equipment. The acceleration of events demands a honing of a whole range of normal photographic skills. With little time to select the exposure, focus on the subject or frame the image, you must make decisions about the viewpoint and timing of the picture in advance. And you need to apply some simple basic techniques such as prefocusing to increase your chances of getting just the picture you want instead of a blurry image half cropped by the frame edge.

Playing children stream *down a massive dune. The photographer waited until the group formed a diagonal composition across the slope before arresting their motion with a fast shutter at 1/500.*

Fast shutter

Action photography calls for a camera with a top shutter speed of 1/1000. Some modern cameras are even faster – as quick as 1/2000, or even 1/4000. But must you use your camera's fastest speed to freeze action, or will a slower speed be sufficient?

The answer obviously depends on how fast your subject is moving, but other factors are important too. For example, the world's fastest sprinter reaches a speed of about 27 miles per hour, and in the course of an exposure lasting 1/1000, his body will have moved forward about half an inch. If you are photographing a whole field of six or eight runners from some distance with a normal lens, then body movement of half an inch is unlikely to be significant, and the picture will look sharp. But if you choose to close in with a powerful telephoto lens and show the strain on the face of the leading runner as he crosses the finishing line, a half-inch movement could make the magnified winner's profile look blurred and indistinct.

In sporting events such as auto racing, in which speeds are many times faster than on a running track, the direction of movement has an even greater bearing on the sharpness. If the subject is moving directly toward or away from the camera, the image in the viewfinder does not move across the frame. Instead, it simply appears to get bigger or smaller, and to arrest this slight change you can use shutter speeds that would be too slow to freeze the same subject passing across the frame, as demonstrated in the sequence below at left.

The chart below at right offers a rough guide to the relative shutter speeds at which you should be able to freeze different kinds of movement. But bear in mind that a host of factors can affect sharpness, including the focal length of your lens and your distance from the subject. You should use these speeds experimentally, and combine them with swinging the camera around to follow the subject – the panning technique explained in detail on pages 32-33.

Movement within the frame
This sequence of photographs of a car traveling at a constant 40 miles per hour was taken at the same shutter speed of 1/125. It shows how you can choose a camera position to stop the subject's movement at relatively slow shutter speeds.

1–With the camera pointing across the road, the passing car appears moderately blurred in the final image.

2–With the camera on the inside of a bend, the car approaches at a 45° angle and appears much sharper.

3–With the camera on the outside of a bend, the car comes almost directly toward it, and is entirely sharp.

Speeds to freeze movement
The chart below indicates the slowest shutter speeds that will stop the movement across the frame of some common subjects. A lot depends on the subject's distance from the camera – the speeds given here are for subjects at a distance that makes them fill the frame of a 35mm camera, held horizontally. Subjects farther away will need slightly slower speeds. If the subject is moving toward or away from the camera, you can allow a speed one or two stops slower than is indicated.

Child sprinting	1/250
Adult running	1/250
Adult sprinting	1/500
Car at 40 m.p.h.	1/500
Car at 80 m.p.h.	1/1000
Fast racing car	1/2000
Fast train	1/1000
Tennis serve	1/1000
Tennis stroke	1/500
Skier	1/1000
Water skier	1/500
Skateboarder	1/500
Cyclist	1/500
Swimmer	1/125
Diver	1/1000
Trotting horse	1/250
Galloping horse	1/1000

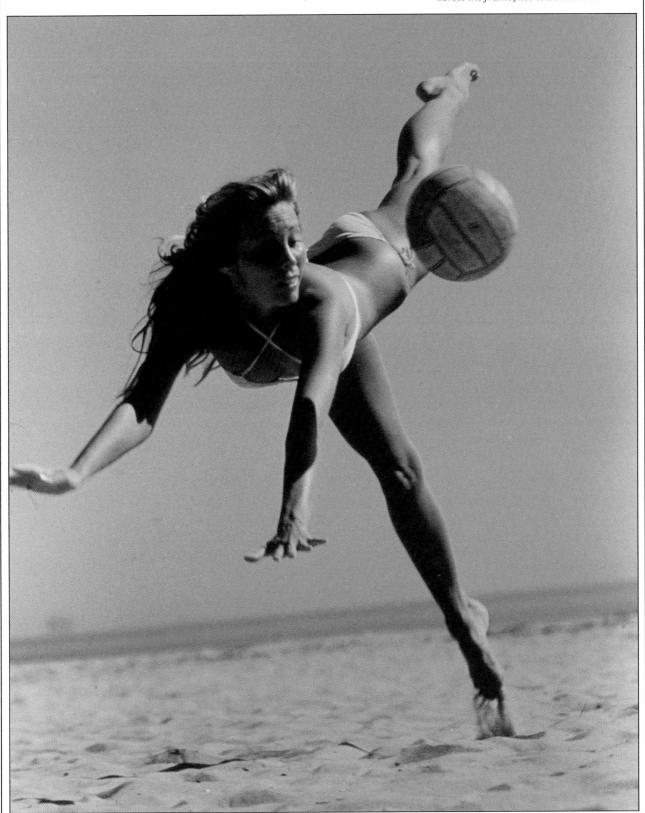

Fast film

Shutter speeds fast enough to freeze rapid action dramatically reduce the amount of light that gets to the film. One solution – often the only one – is to use faster film, as outlined in the table at right.

To freeze the action of the circus performer below, the photographer had to use a shutter speed of 1/500. With a medium-speed film, the dim lighting of the big top would have forced him to use an aperture of f/1.8 – impractical because his lens had a maximum aperture of f/4. Loading the camera with ISO 400 film enabled him to capture the scene with the f/4 aperture.

In exceptionally bad light, even the fastest film may not be sufficiently sensitive. But by increasing the development time of color slide or black-and-white film during processing – a technique called pushing the film – you may be able to wring out a little extra speed. To use this technique – illustrated at the bottom of the opposite page – you set the camera's film speed dial at one or two stops above the ISO rating of the film you are using. Then, when you send the film to a laboratory, ask the processor to increase development equivalently.

The availability of fast film
The 35mm format offers the broadest range of fast films, with medium-format 120 film only a short way behind. Small formats, such as 110, offer limited choice.

Color prints

For 35mm cameras, the fastest color print film has a speed of ISO 1000, but for other types of camera, the fastest available film is slightly less sensitive than this – ISO 400.

Color slides

In 120 and 35mm formats, the fastest color slide film has a speed of ISO 400. However, special processing can increase this speed to ISO 800 or even 1600 (see box opposite below).

Black-and-white

Regular black-and-white films have speeds up to ISO 400, or ISO 1600 with special processing. New types, processed in color chemicals, can be routinely rated at ISO 1600.

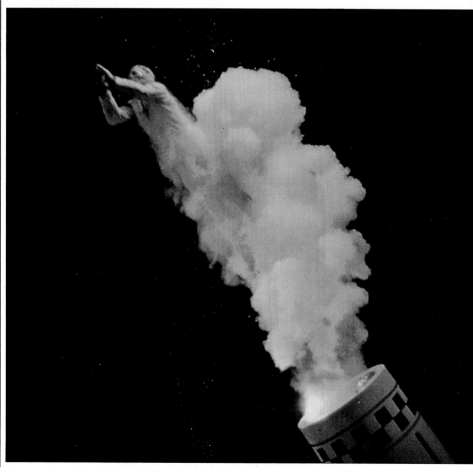

A human canonball speeds toward the safety net. The photographer used a 200mm lens from a normal seat in the circus tent, with fast ISO 400 film.

At a harness race, rapidly fading sunlight casts a warm glow on a horse and driver. Only by using a film with a speed of ISO 400 was the photographer able to catch a sharp double image (1/250 at f/2.8, 135mm lens).

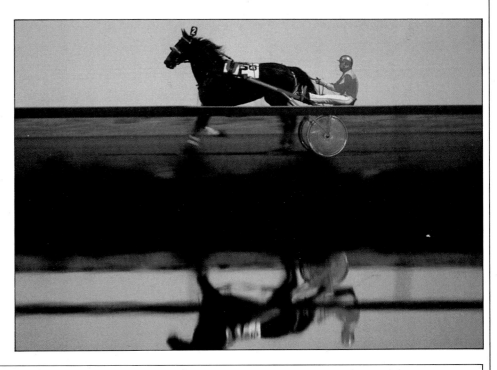

Pushing film
For the sequence below, the photographer progressively uprated the film speed to achieve faster shutter speeds and less blur, thus effectively underexposing. The processor then "pushed" the film's development time to compensate.

Developed normally, ISO 400 film has good color, but dim light forced the photographer to use a speed of 1/60, so movement has blurred the picture.

By uprating the film one stop (to 800), the photographer got a sharper picture at a speed of 1/125. But longer development dulled the colors.

Pushing film too far can cut image quality. Here a three-stop push made possible a shutter speed of 1/500 but the colors are unacceptable.

Fast lenses

For action photography, a fast lens – one that has a large maximum aperture – is of special value. Because a fast lens gathers more light than does a regular lens, it produces a brighter viewfinder image, and is therefore easier to focus. And because of the amount of light admitted at open aperture, a fast lens allows you to set a rapid shutter speed, even in poor light. This makes it easier to freeze action in conditions that would normally force you to blur movement with a longer exposure.

The maximum aperture of a fast lens may be only one or two stops wider than that of a regular lens of the same focal length, but this can sometimes make the difference between a sharp, clear image and one that is spoiled by subject or camera movement. This is particularly true when you use a telephoto lens, which will in any case have a smaller maximum aperture than a normal or wide-angle lens, as explained in the box below. A further discussion of using telephotos is on pages 38-39.

If you intend to take many action pictures, a fast lens may make possible pictures you otherwise could not take, such as that of the dancer at right. For this picture, the photographer used a fast 100mm lens at its maximum aperture of f/2. This enabled him to set a shutter speed of 1/250 – just fast enough to record the dancer's gyrations without blur in the poor light.

Although fast lenses undoubtedly help you to cope with difficult lighting conditions, they have some disadvantages. The more complex construction of fast lenses often makes them costlier, heavier or more bulky than standard lenses of equivalent focal lengths. For example, the 55mm f/1.2 lens shown below was three times as heavy as a 50mm f/1.8 lens, and actually cost twice as much to buy.

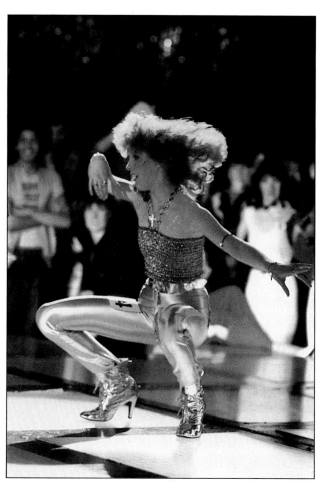

A disco performer whirls through a dance competition. The bright viewfinder of a fast lens made it easier to focus on the gyrating figure, intermittently lit by flashing lights.

Fast lenses

If you intend to take many action pictures, the extra light-gathering power of fast lenses such as those shown here will probably justify the increased cost and weight. Fast wide-angle lenses outwardly resemble those with narrower apertures. Only the weight indicates their greater internal complexity. On the other hand, fast telephoto lenses (see opposite page), are both heavier and much larger than slower telephotos.

28mm f/2

If you can get close to the action, a fast 28mm lens produces a dramatic perspective and is very easy to use – focusing is virtually unnecessary.

35mm f/2

A 35mm lens lets you get farther back without the subject looking too small in the frame. Some models are as much as a stop faster than the f/2 lens shown here.

50mm f/1.2

The 50 and 55mm lenses are fastest of all – apertures of f/1.2 are commonplace. They allow you to use fast shutter speeds to freeze action in poor light.

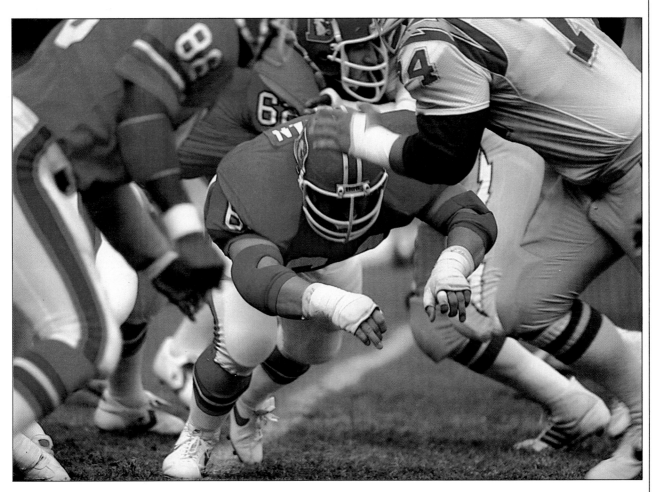

A football player ducks low, fixed by an exposure of 1/500. A photographer on the sideline obtained this shutter speed with a fast 300mm lens wide open at f/4.

100mm f/2

Particularly with sports, you will need a longer focal length to get close to the action. The 100mm f/2 lens above provides useful magnification.

200mm f/2.8

This 200mm f/2.8 lens is almost as fast as a 50mm lens, yet will frame a running figure tightly at a distance of 50 feet from a track event.

300mm f/4

For dramatic close-ups of more distant action, you may need even longer lenses. But f/4 is fast for a 300mm lens, and bulk is considerably increased.

600mm f/4.5

This 600mm f/4.5 is one of the remarkable modern lenses capable of giving wide maximum apertures coupled with very high magnification.

The peak of the action

To get maximum impact into an action picture, you need to add a sense of timing to skillful use of your equipment. With every moving subject, there are certain positions that, when caught in a photograph, seem to encapsulate the action. The moment of crossing a high-jump bar, as in the picture at the bottom of this page, is one such example. Pictures of the jumper running in, springing or descending would all have had less drama than this image of her grazing the bar, a hairsbreadth away from failure.

Such pictures are rarely the result of luck. If you take a rapid sequence hoping that one picture will be just right, you will find that the peak moment often falls between frames and is missed. Instead, study the pattern of the action beforehand and attempt to anticipate what will happen so you can plan to press the shutter release at a predetermined peak point – ideally a fraction of a second earlier, to allow for the delay in your reaction. In some events, the subject may be almost stationary, as are the high jumper below and the motorcyclist opposite – suspended in midair at the high point of a jump. Thus, choosing the peak often gives you the best chance to capture a sharp, well-framed image.

Some peaks in the action are fairly obvious. In ball sports, you should usually make sure the ball is in the picture, and the actual impact with the ball is often the best moment to anticipate. But look also for peak moments of a different kind, as captured in the golfing sequence below.

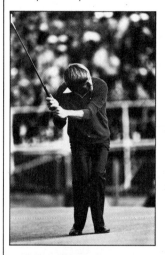
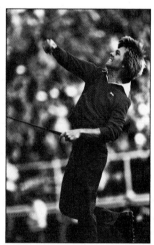
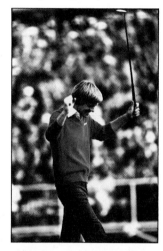

Winning the British Open, U.S. golfer Bill Rogers shows his elation by hurling his golf ball (center picture in the sequence at left) into the crowd. The photographer planned to catch the exact moment of this customary victory throw and set a speed of 1/500. Although he also took pictures capturing the tension as the ball slowly trickled toward the hole and an enthusiastic gesture after the throw, neither of these images has the force of the anticipated peak.

Clearing the bar, (left) a high jumper seems to hang momentarily in midair. For this split-second pause the photographer knew that he could use a shutter speed of 1/250 and still stop the athlete to reveal the full drama of the moment.

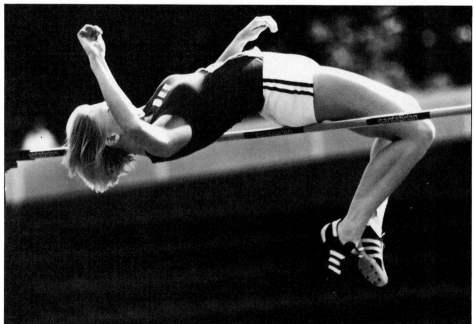

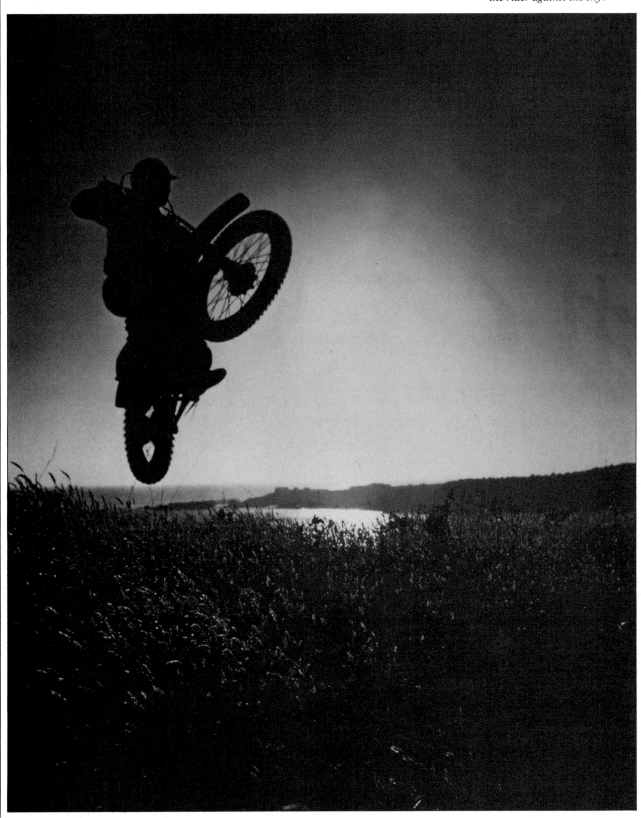

Leaping the crest of a hill, a motorcycle rider takes to the air. Predicting the jump, the photographer underexposed to silhouette the rider against the sky.

Choosing the viewpoint

A carefully selected camera position can make the difference between a static, uninteresting picture and a remarkable image that puts the viewer in the very thick of the action. Often you will be able to pick a good viewpoint simply by studying the pattern of play in a game or an event. For example, the picture below exploits the hectic, compressed action that takes place around the goal mouth during a good match. The photographer approached a small-town ice-hockey team and secured their cooperation for a special photo session – which they were delighted to give during practice. This wide-angle photograph was taken with a camera placed close to the action and triggered by a cable release. Such positions are inaccessible during a real game and you need to close in with a telephoto lens. But the aim should be the same – to find a viewpoint that

will give you plenty of action, which you can condense easily into a tightly framed image.

In races, the speed of the subject's movement in relation to the camera's viewpoint is a prior consideration. Unless the light is bright enough for a very fast shutter speed, you may need to place yourself near the start, on a bend or in some other position that gives you a head-on view. In this way you should be able to avoid unwanted blurring of the subject or background. Consider also whether the background will confuse the image or clarify it, as in the picture at right of a climber against the sky. Both the climbing picture and that of a diver next to it show adventurous uses of viewpoint to express the feeling of an action. A camera angled upward or downward can give the viewer a powerful sense of participation, of "being there."

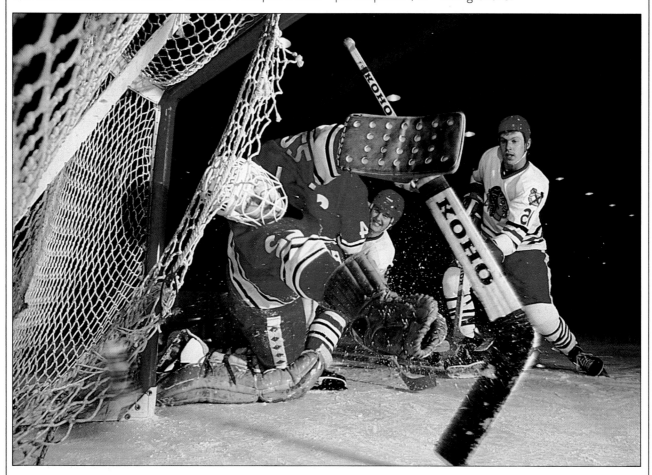

An on-camera flash catches a flurry of action during a practice game. The photographer placed the camera on the ice inside the goal and used a cable release.

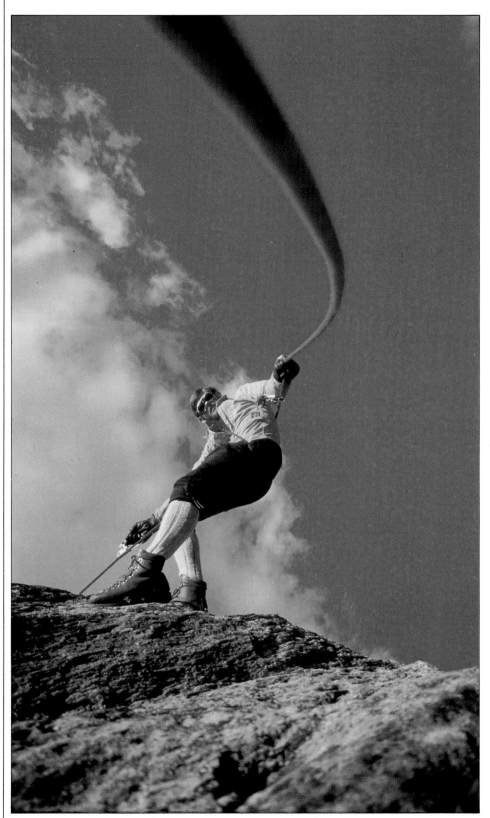

A descending climber (left) is etched against the sky. The rope looping past the photographer's 24 mm wide-angle lens gives a powerful sense of the action and the drama as the camera points upward.

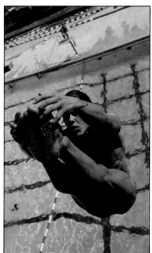

Jack-knifing in a back somersault (above), a diver at practice is caught just before he straightens for the plunge. The photographer, on a higher platform, used a shutter speed of 1/500. The tilt of the camera helps to convey the dizzying height.

Prefocusing

The furious pace of much action photography means that maintaining a clearly focused subject at all times is impossible, especially with telephoto lenses. Prefocusing is an invaluable technique. You determine where the best of the action should happen, focus on that spot, and wait for the subject to reach it.

First, you need to be able to anticipate the activity so that you can select a suitable point on which to focus. Sometimes, this will be obvious – as in the picture of the couple running toward the camera, opposite. But often you will need to observe the action for a while before deciding the point of focus. If necessary, you can mark the focusing distance for future reference, as shown at right below.

A more critical judgment is timing. Press the shutter release a fraction too soon or too late, and the subject will be out of focus. With a telephoto lens, there is even less margin for error because of

the shallower depth of field. The trick is to anticipate the moment at which the subject will reach the point of focus, and shoot a fraction of a second before. For your first attempts, try prefocusing on a fixed, well-defined area. Take the example of a horse clearing a jump at left below. You can prefocus on the top of the rail in the knowledge that the animal must pass that spot. Having focused, follow the subject until the leading foreleg has just crossed the bar – then shoot. This allows for your reaction time, giving you a perfectly focused image.

Any sport that follows a fixed course provides good practice for prefocusing. As you become more skilled, you should extend the technique to cover more unpredictable situations. Sometimes you may even need to estimate the focus for a point in midair – perhaps a skier's jump. In this case, simply prefocus on an equally distant point on the ground below.

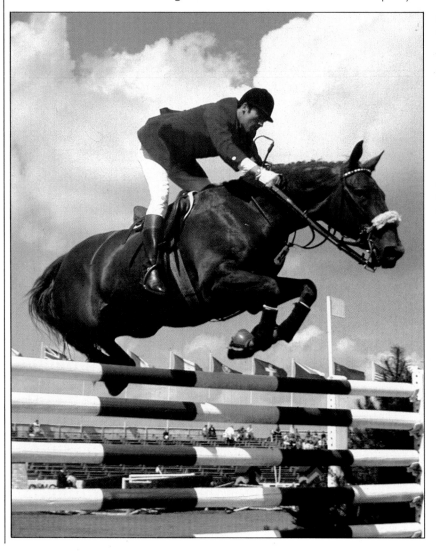

Marking focusing distance
The focusing ring of the lens above is marked with crayons at around 20 and 40 feet as a guide to photographing the service and net positions in a tennis match from a single camera position. You can use this technique as an aid when you want to return the focus to some predetermined setting after taking other pictures at different distances. Thus, the owner of the camera above, by using the two color-coded settings, did not need to refocus visually each time he swung his camera between the two parts of the action that interested him.

A horse and rider are stopped in mid-jump. The fence rails provided the photographer with an ideal prefocusing spot. As soon as the forelegs came into focus, he pressed the shutter release.

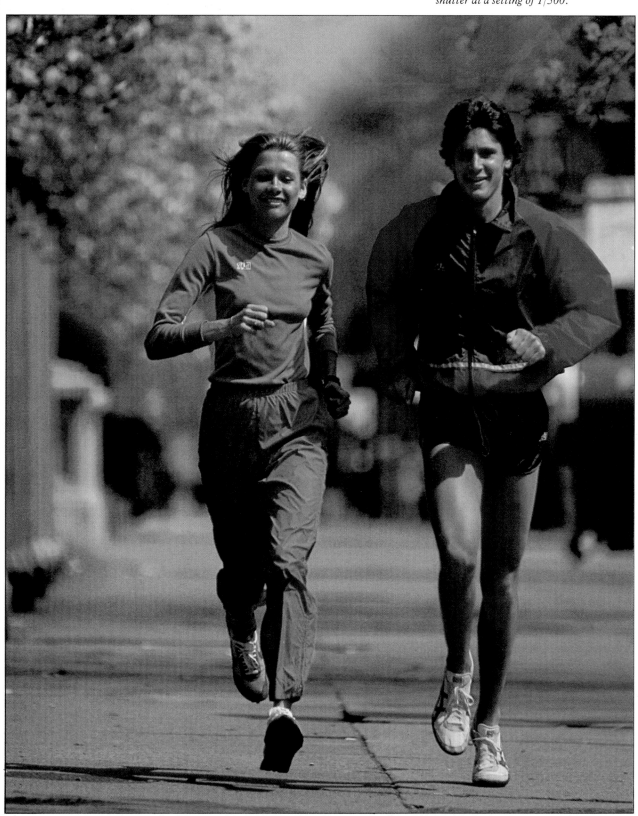

Jogging companions pound along a quiet sidewalk. The photographer noted the couple approaching and prefocused on a spot ahead, then waited until they were just coming into focus to fire the shutter at a setting of 1/500.

Suggesting movement with composition

To achieve a clear overall image in action photography, you must use a shutter speed fast enough to stop the subject's movement. However, unless you carefully choose your moment to shoot, this technique can result in a disappointingly lifeless picture. A racing car at top speed, frozen against a clear, sharp background, can look as if it has just been parked for the day. To prevent this kind of paralysis, you need to find something in the scene that suggests life and movement.

The best stopped-action pictures often include an element of impending shock or disaster. In the surfing picture opposite, a very fast shutter speed arrested not only the surfer but also the motion of the water. But both the toppling wave and the angle of the man's body convey an irresistible sense of speed. To get this atmosphere of "it's all about to happen," try to take your picture an instant before the anticipated action – as in the image of the junior baseball ace at right. In this way, you make the static image seem part of a continuum and invite the viewer to look forward to the outcome.

With human or animal subjects, body positions are powerful indicators of movement and speed. One reason why vehicles tend to look stationary when shown sharply in a picture is that no matter how fast they travel, their shapes and angles with the ground are the same. On the other hand, when people move, their feet rise in the air, their arms swing out, and their bodies balance at seemingly impossible angles. So even when an entire image is frozen, we get an impression of motion because we know people do not look like this at rest.

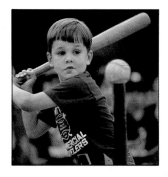

A young hitter eyes the ball before swinging. The twist of the body conveys his energy and concentration and implies the imminent movement. A shutter speed of 1/250 was sufficient to stop the action before the more explosive strike.

The balletic movements of two boys playing on the beach contrast with the leisurely pace of a couple strolling by. The photographer used ISO 64 film and set an exposure of 1/250 at f/8 to get a clear, sharp image with good background detail.

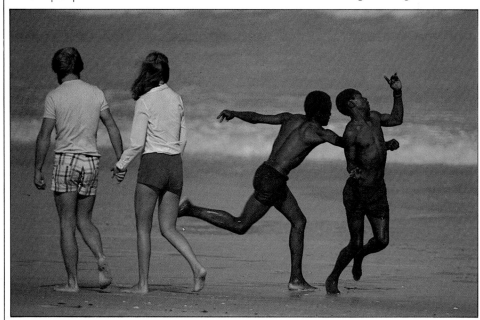

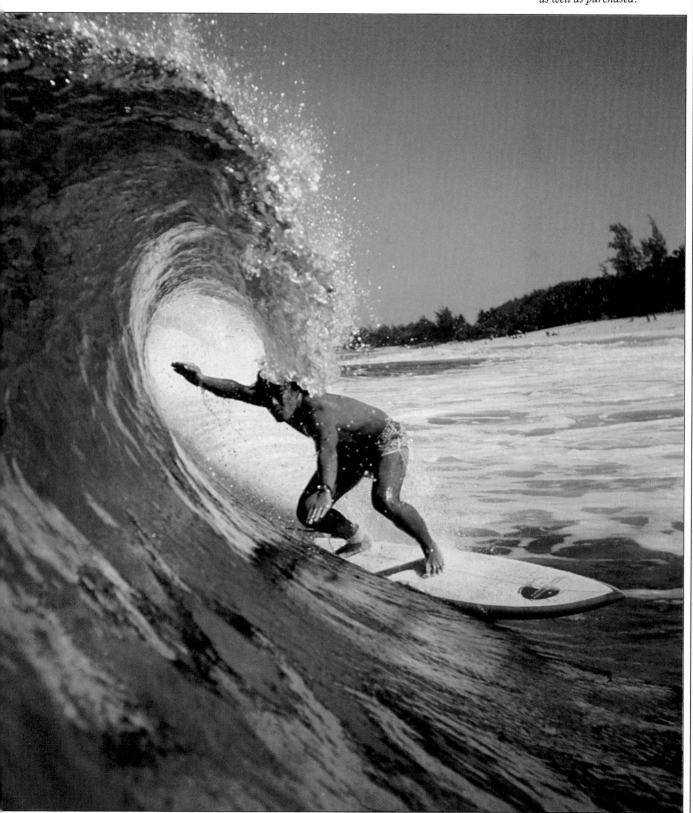

A curling wave threatens to swamp a surfer, fixed by a shutter speed of 1/1000. The photographer had a watertight camera – these can be rented as well as purchased.

Panning

By following a moving subject across the frame with your camera during exposure, you effectively reduce the rate of movement. Panning, as this technique is called, enables you to use a relatively slow shutter speed to stop action, while creating background blur to help suggest movement.

In some areas of high-speed photography, panning is essential if you want a sharp image of the subject. With a static camera position, even a shutter speed of 1/2000 may not be fast enough to freeze a racing car or motorcycle traveling across the frame close to you. But by panning you can obtain the kind of crisp image illustrated at the bottom of this page. In an absolutely sharp panned picture the speed of the subject relative to the movement of the camera during the exposure is zero. By slowing the shutter speed and the speed of the panning movement, you can blur or streak the subject: Against a colorful background, slight blurring can suggest a whirling velocity, as in the photograph at right.

Whatever the subject and shutter speed, the basic object of panning is to achieve a smooth, continuous movement of the camera. Start by assessing in advance the course that the subject will take, and prefocus on the spot at which you estimate the subject will pass closest to you. Stand facing this spot with your shoulders parallel to the subject's line, and set a shutter speed of around 1/60 or 1/125, depending on the subject's speed. As the subject approaches, without moving your feet, swivel your hips round to pick it up in the viewfinder. Keep the subject in the center of the frame until it is almost directly in front of you and then press the shutter release. Remember to follow through smoothly after the exposure to avoid any image distortion.

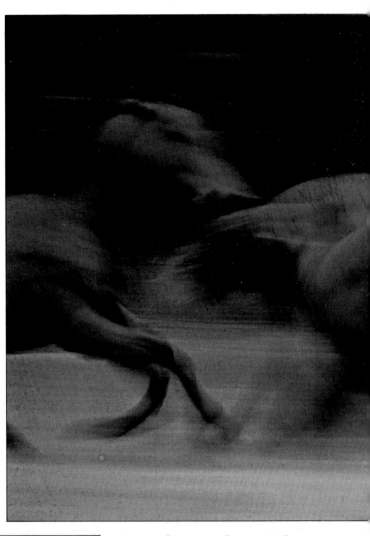

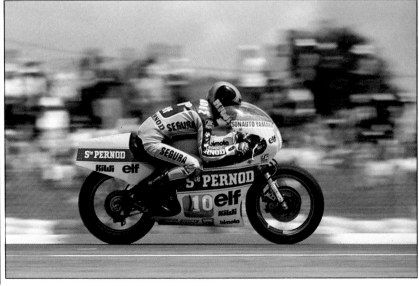

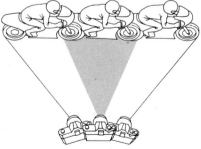

Accurate panning, as diagrammed above, froze the movement of the racing motorcycle at left. The photographer selected a shutter speed of 1/1000 and pressed the shutter release in the middle of the swivelling motion plotted in the diagram. This ensured a sharp image in the exact center of the frame.

Horses racing across a field convey
the joy of free movement. Fast panning
at 1/60 recorded the main subject's head
and shoulders crisply: but the galloping
hooves, the other horses and the verdant
surroundings have streaked and blurred.

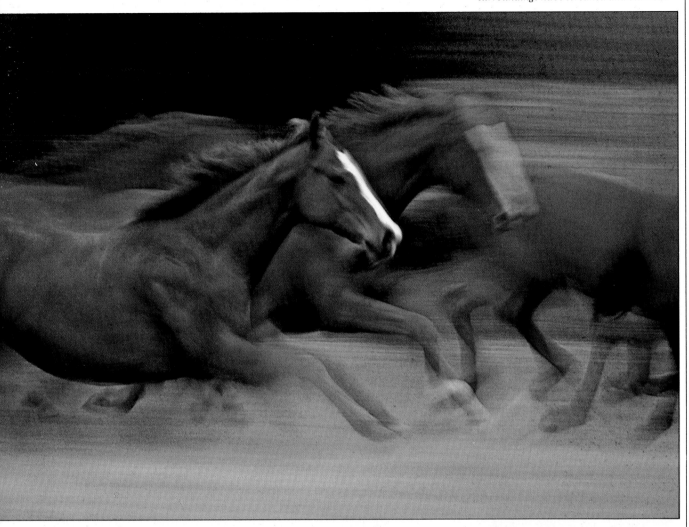

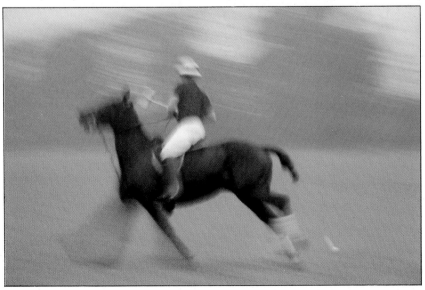

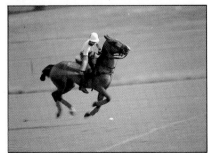

Polo ponies, photographed at two
different shutter speeds, show how the
effects of panning can be controlled.
The photographer set a shutter speed of
1/8 for the picture at left in order to
creatively mask all detail. At 1/125,
panning has stopped the pony – but has
only just blurred the background.

The background

In action photography, you can very easily get so caught up by what is happening in front of you that you forget about the background. Ideally, the background should complement the subject and make the action stand out clearly and sharply.

Color and tonal values are very important – even a completely plain background can lessen the impact of a picture if there is not sufficient contrast with the subject. Worse, a clutter of shapes or bright colors in the surroundings will spoil an otherwise superb shot. For example, a crowd will be a considerable distraction if recorded in sharp detail. Setting a wide aperture to limit depth of field is one solution: you retain the atmosphere of a crowd, but only as a soft blur. A useful tip when you are shooting in good light is to use a faster shutter than you need to stop the action, so that you can set a wider aperture. But be careful when using a wide aperture, for accurate focusing becomes more important than ever. Telephoto lenses, with their shallow depth of field are very effective in separating the subject from the background, as illustrated at right.

Remember the background can contribute positively to the mood and movement of action pictures. Distracting billboards can become streaks of moving color in a panned shot. In some special circumstances, you can use the background in a controlled way as a major element of an action picture – for example, in the picture of the hang glider silhouetted against the evening sky below.

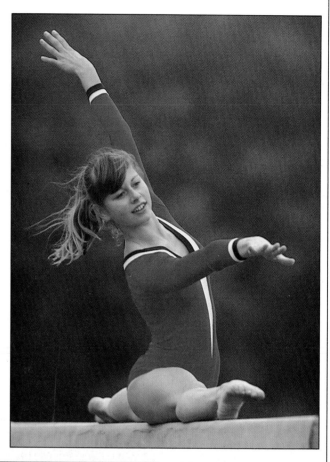

A lithe young gymnast holds her balance on a bar. The photographer used a 200mm lens at a wide aperture setting – f/4 – to throw the trees behind out of focus and create a smooth, soft backdrop for the subject.

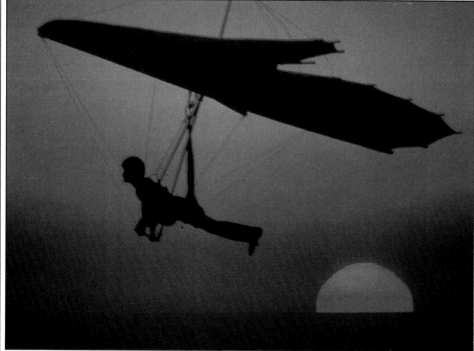

A hang glider cruises across the sky at sunset. In bright daylight, much of the subject's dramatic shape would have been lost. The photographer used a 600mm lens with ISO 200 film and set a speed of 1/500 at f/16 to underexpose the image and emphasize the graphic tonal contrast within the scene.

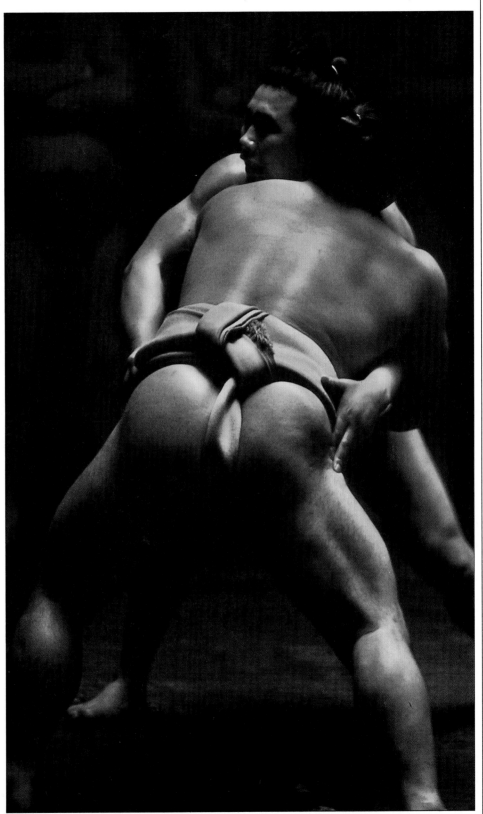

Huge Sumo wrestlers come to grips in the ring. The formal stance of others waiting their turn behind suggests the ritual nature of the action, but because these background figures are in shadow and their heads are cropped out, they do not distract attention from the contest.